D0808310

BP PORTRAIT AWARD 2017

National Portrait Gallery

Published in Great Britain by National
Portrait Gallery Publications
National Portrait Gallery
St Martin's Place, London WC2H 0HE

Published to accompany the BP Portrait
Award 2017, held at the National Portrait
Gallery, London, from 22 June to
24 September 2017, Royal Albert
Memorial Museum & Art Gallery, Exeter,
from 4 October to 3 December 2017,
Scottish National Portrait Gallery, Edinburgh,
from December 2017 to March 2018 and
Sunderland Museum and Winter Garden,
from March to June 2018.

For a complete catalogue of current
publications please write to the address
above, or visit our website at
www.npg.org.uk/publications

ISBN 978 1 85514 780 5

A catalogue record for this book is
available from the British Library.

10 9 8 7 6 5 4 3 2

Managing Editor: Christopher Tinker
Project Editor: Kathleen Bloomfield
Design: Richard Ardagh Studio
Production: Ruth Müller-Wirth
Photography: Prudence Cuming
Printed and bound in Italy
Cover: *Corinne* by Anastasia Pollard

Every purchase supports the
National Portrait Gallery, London

Supported by BP

FSC
www.fsc.org
MIX
Paper from
responsible sources
FSC® C016114

CONTENTS

DIRECTOR'S FOREWORD

The judging stages of the BP Portrait Award are an opportunity to see some of the most exciting and innovative work being produced by artists of all ages, and from all over the world. This year we received 2,580 entries from eighty-seven countries, and in the initial, digital judging session we scrutinised each and every one of these paintings before selecting just a few hundred for the second round – our first chance to see the longlisted works in the flesh. Canvases and boards of all sizes arrived in London, and over two days we gradually whittled down the selection to just fifty-three outstanding portraits for the exhibition.

Certain names inevitably crop up again and again, despite the anonymous judging process – since the competition, recognised as the most prestigious in the field of portrait painting in the world, continues to attract the best practitioners of the medium. This year is no exception. The overall winner, whom the eagle-eyed will remember as the recipient of third prize in 2016, is Benjamin Sullivan. His portrait, *Breech!*, depicts his wife and their young baby. The judges were struck by the tenderness and intimacy of Benjamin's composition. Our congratulations also go to Thomas Ehretsmann and Antony Williams – winners of second prize and third prize respectively – both of whom, like this year's winning artist, have produced works that have been selected for the exhibition on previous occasions.

At the National Portrait Gallery we are grateful to BP for their sponsorship, now in its twenty-eighth year, of the Portrait Award and for their support of the entire exhibition programme. The provision of the Travel Award has enabled established artists to undertake projects in countries including Japan, Peru, Burkina Faso and, this year, in Greece. At the same time, participants in the BP Next Generation workshops may look for inspiration to this year's Young Artist Award winner, Henry Christian-Slane, as they develop their skills. We may even see one of their portraits hanging in the exhibition in a few years' time. My thanks, once again, go to Bob Dudley and his team, and in particular to Dev Sanyal, Peter Mather and Des Violaris for their commitment to the success of this partnership.

Nicholas Cullinan
Director, National Portrait Gallery

SPONSOR'S FOREWORD

Every year the BP Portrait Award helps to encourage and inspire thousands of portrait artists to capture the stories of people from every walk of life and in all corners of the world. Their artworks provide a multi-layered and diverse view of global society in fast-changing times, offering a different perspective to the billions of images captured every second of every day by social and traditional media sources. The exhibition of portraits painted by award winners since 1990, which has been shown in Hull during its year as the UK City of Culture, strongly reminds me of this.

This year over 2,500 artists from eighty-seven different countries have submitted works, with fifty-three paintings selected by the judges for this exhibition and catalogue. I always look forward to seeing the new exhibition, studying the different approaches and techniques used, and discovering the stories connecting every image, artist and sitter.

My personal thanks go to the judges for their commitment to the challenging process of narrowing down so many entries into a shortlist, and for their expertise in determining the portraits that most deserve to win from a very strong exhibition.

As always, it is a pleasure to work with our partners at the National Portrait Gallery. Our aim in supporting this award, and other cultural activities in the UK, is to bring to as wide an audience as possible the very best in arts and culture. Dr Nicholas Cullinan, Pim Baxter, and their team at the Gallery do an excellent job, as demonstrated by the popularity of the exhibition with the public and the interest shown by artists not only in the award itself, but also in supporting the programme of workshops with schoolchildren and young people. BP's partnership with the National Portrait Gallery is now in its twenty-eighth year, and we are delighted that it will continue through to 2022.

On behalf of BP, I would like to thank all the artists who submitted work this year and congratulate those who have been selected for the exhibition and shortlisted for the awards.

Bob Dudley
Group Chief Executive, BP

PORTRAITURE –
THE PROBLEM AND THE SOLUTION

Stella Duffy
Writer

The problem with portraiture is the same as the problem with history; almost always written by the victor, the story is told from just one angle, the chronicle of the conqueror. How we got to now can never be fully retold in a single narrative, there is no one story that can hold all the threads that bring us to this time and this place, and lead us on into the future.

In the case of portraiture, the story most often told in Britain has been that of the great white male: the man of privilege, the man of destiny, the man born to make a mark. It doesn't matter that the Gallery's collections are carefully curated, with well-written explanations to elucidate, nor does it matter that these are the portraits that we have – the Gallery cannot, after all, magic up portraits of unknown working-class men, or of women who were not rare queens or (less rare) whores. This Collection is what we have available to us, and because of our history it necessarily reveals (part of, less than half of) the story of our nations. These are not complaints or carping, they are truths. What matters is that we notice the women who are not part of the story, the people of colour who are not on the walls. They were there in our past, we are here now, and if we have anything to learn from the narrative of art's history, it is that in the present passing, we can make a difference. We can choose, as the Gallery often does, to put portraits of women on the cover of a leaflet, even if women make up just over a quarter of the subjects. We can choose to notice the lack of people of colour in the rooms of past centuries, people who were part of everyday Britain from Roman times and perhaps even earlier. We can acknowledge that it was the rich who had the time and money to be painted, and that, even in the twentieth century, photographic equipment was too expensive for most people, so that our photographs are often of the wealthiest of our population.

Acknowledging all of this does not diminish the Collection. Placing it in a socio-economic context is as useful to our understanding of the work as a rudimentary knowledge of art history. Knowing what is missing, who is missing, supports us in understanding what we are seeing today. Like many people, much as I have some interest in representations of celebrity (kings, queens, mistresses, poets, generals), I am also interested in 'ordinary' people, those who have not achieved through privilege, but merely through living a life, often in the most difficult of circumstances. I am, like most of us, interested in people like me – it is especially hopeful then that the Gallery is actively working to acquire portraits of those 'ordinary' people who made extraordinary contributions, and who may have been missed by the curators of previous generations.

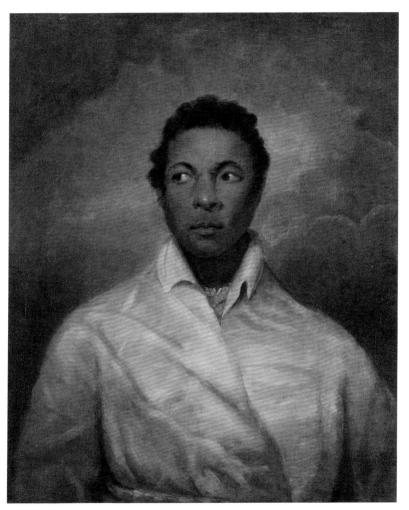

Ira Frederick Aldridge (1807–67)
after James Northcote, c.1826 (NPG L251)
Oil on canvas, 763 x 632mm

My life was changed by an ordinary–extraordinary meeting with someone like me who was working in the arts. I am the youngest of seven children, born on a council estate in south London and raised in a small timber town in New Zealand, hours from the closest theatre, gallery or museum. My parents left school at fourteen, my siblings at sixteen. I knew I wanted to work in the arts and neither I, nor anyone in my family or immediate social circle, had any idea how someone like me could get there. When I was fifteen, a touring theatre company performed *Hamlet* at my school – and no, lovers of Shakespeare, it was not the writing that changed my life. It had nothing to do with the quality, or otherwise, of the production. What made all the difference was that *someone like me* was in the cast. One of the actors was the big brother of my friend from primary school. His dad worked at the timber mill, just like my mum and dad. *Someone like me* was being an artist. That made the difference. I still didn't know how I personally would get there, but because I saw myself reflected among the actors performing on our school hall's wooden floor, I understood that people like me could work in the arts. This is why I am drawn to the images of those individuals whose inclusion in the Collection was not a given simply through inheritance of privilege.

The Gallery's portrait of Ira Aldridge (c.1826), after James Northcote, is a powerful example of this impact. Here is a young black man, beautiful, thoughtful, wary. Born in New York in 1807, he emigrated to Liverpool in 1824, having already established himself as a young actor. His appearance as Othello at the Theatre Royal, Covent Garden in April 1833, at the time when slavery in British colonies was being fiercely debated in Parliament, led to intensely divided reviews, many commenting on the impossibility of an 'African' having any understanding of Shakespeare's language or intent. Across the river however, at the Surrey Theatre in Lambeth, he found success and acclaim for the same work. The presence of Aldridge's portrait in the Collection is far more than simply a celebration of his success or fame, although he had both. It adds an emotional context to a major stepping stone in British politics – in August 1833 Royal Assent was granted for the Abolition of Slavery in British Colonies.

I feel a similar mix of joy and sadness standing in front of John Opie's c.1797 portrait of Mary Wollstonecraft. Here is a woman who campaigned for freedom from slavery for those who were literally enchained by the slave trade, as well as for freedom for women from the slavery that was – that is still, in too many lives, in too many nations – their subordination to men. In the twenty-first century we have neither freed all women from this oppression, either on a global or a local scale, nor have we eradicated slavery in all its forms. Wollstonecraft is dressed simply, and the portrait has a beguiling calm that belies the force of her own work. It is particularly poignant to note that she was pregnant with her second daughter at the time of sitting for this portrait, and that she died of post-partum

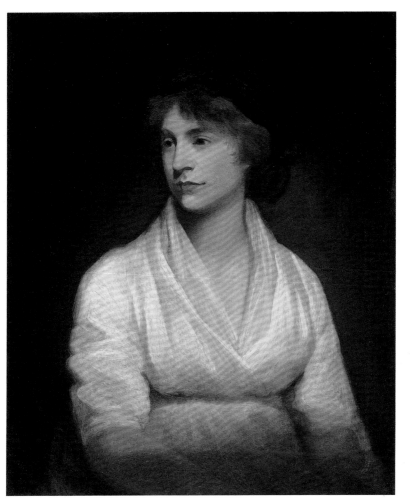

Mary Wollstonecraft (1759–97)
by John Opie, c.1797 (NPG 1237)
Oil on canvas, 768 x 641mm

septicaemia less than two weeks after the birth. That child grew up to be Mary Shelley, whose novel *Frankenstein; or, the Modern Prometheus* (1818) was published when she was just twenty years old. It is impossible for me to separate my emotional response to Opie's quiet, elegant portrait from my personal understanding of the immense value that Wollstonecraft created in her short life. Her presence is vital to the Collection and my experience of the Gallery would be lesser without it.

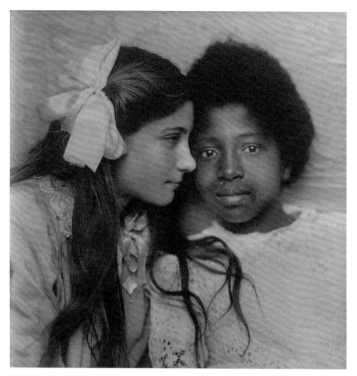

Unidentified sitters
by Marcus Adams, mid-1910s (NPG x199435)
Platinum print, 116 x 112mm

It is no surprise to me that it is with the advent of photographic portraits that I begin to feel more at ease in the Gallery. Marcus Adams's photograph of unidentified sitters from a little over a century ago stands out in startling contrast to the plethora of men, the overwhelming presence of white people, and to the Gallery's own collection of Adams's photographs, the majority of which are of royalty. We see two girls, young women, who are clearly not part of the establishment which otherwise rules these walls. We know this not least because they are not named – and it is the portraits of unknown, unnamed people that interest me most. Because they are unknown, unnamed, I can look back at that young black girl looking out at me, with her uncovered hair, her clear eyes, and I can feed into her story from my own knowledge of history and society. I know nothing about her personally, but because she is not already-famous, already-known, I look at her portrait and feel a kinship in a way that I simply do not when I look at the exquisite but remote images of the queens, the actresses, the mistresses, and the women

artists. These girls make me feel more welcome because they are people like me – and, after all, with my background, I am more like most of the visitors to the Gallery (more like most of the staff too, from cleaners to attendants to the Board of Trustees) than the aristocracy and the politicians who make up the majority of the Collection. It is only when we see ourselves reflected in the arts, that we know the arts are ours.

Which brings me to the fourth portrait that quickened my heart in my visits while writing this essay. I love the lions in Trafalgar Square. I was born in Woolwich, south London. When I was five years old we emigrated to my father's native New Zealand – in the Royal New Zealand Air Force since 1939, he married my mother after the War. A week or so before we left, we went 'up town' to say goodbye to the lions. I returned to London in 1986 and have lived here ever since. Decades ago I made up my own superstition: touching the front paws of each of the four lions will ensure your return to London. I've shared this invented superstition (is there any other kind?) with others, and many of them have made their own pilgrimage to touch the paws. The boys in my novel, *London Lies Beneath*, do so too, and seeing this painting of Edwin Landseer (c.1865), knowing a little of his mental health problems, knowing that the lions really are art for all – the millions who have reached up to stroke their heavy paws, sat on them for photographs,

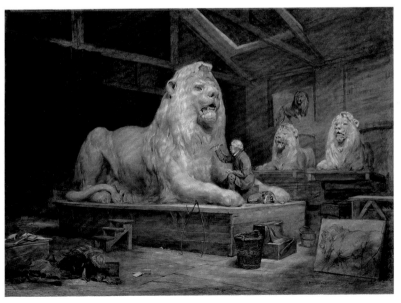

Edwin Landseer (1802 – 73)
by John Ballantyne, c.1865 (NPG 835)
Oil on canvas, 800 x 1130mm

protested from them, partied around them – give weight to John Ballantyne's image of an artist at work. It is never just the subject that gives significance to a portrait, it is what the artist includes and chooses to exclude – from the sitter's own life, from the society of the time and its contrast with our time, along with their understanding and interpretation. These are the layers that make portraiture sing for me. This, and the hope that one day all our galleries will be as genuinely open and welcoming to all as the paving around the feet of Landseer's lions – by which I mean that the doors will not simply be open, but that everyone will feel emotionally, personally, able to enter and join in with the arts, no longer wondering how do 'people like me' make our way into that world.

Those of us who are passionate about cultural democracy believe that in time and with real effort our galleries will be more inclusive, more diverse – as will our stages, concert halls and screens. We will begin to see all of us reflected back, we will see ourselves in our beautiful multiplicity and our citizens will know that each one of them is valued by the arts for who they are and for their individual contribution to society. In order to get there, new artists, new subjects, new portraits must be created that reflect our present truths – in this way, portraiture can offer not only the solution, but it can be the saving grace, the vital forward step. When we acknowledge what is missing – who is missing – we know where to concentrate our next efforts. When the wide mix of people who are Britain today see themselves reflected and respected in all of our arts – then we will be able to say that our arts are truly for all. The wider we throw that net, the broader and deeper the art and artists it will encompass – and that will not only be good for the people, it will be good for the arts as well.

Stella Duffy is a writer, theatremaker, and the co-director of Fun Palaces, an ongoing campaign for cultural democracy with an annual weekend of action every October. Her latest novel is *London Lies Beneath* (Virago).

BP PORTRAIT AWARD 2017

The Portrait Award, in its thirty-eighth year at the National Portrait Gallery and its twenty-eighth year of sponsorship by BP, is an annual event aimed at encouraging young artists to focus on and develop the theme of portraiture in their work. The competition is open to everyone aged eighteen and over, in recognition of the outstanding and innovative work currently being produced by artists of all ages.

THE JUDGES

Chair: Nicholas Cullinan,
Director,
National Portrait Gallery

Sarah Howgate,
Contemporary Curator,
National Portrait Gallery

Michael Landy,
Artist

Kirsty Wark,
Broadcaster and journalist

Camilla Hampshire,
Museums Manager & Cultural Lead,
Royal Albert Memorial Museum & Art
Gallery, Exeter

Des Violaris,
Director, UK Arts & Culture, BP

THE PRIZES
The BP Portrait Awards are:

First Prize
£30,000, plus at the Gallery's discretion a commission worth £5,000.
Benjamin Sullivan

Second Prize
£10,000
Thomas Ehretsmann

Third Prize
£8,000
Antony Williams

BP Young Artist Award
£7,000
Henry Christian-Slane

PRIZEWINNING
PORTRAITS

Breech!
Benjamin Sullivan

Oil on canvas
820 x 400mm

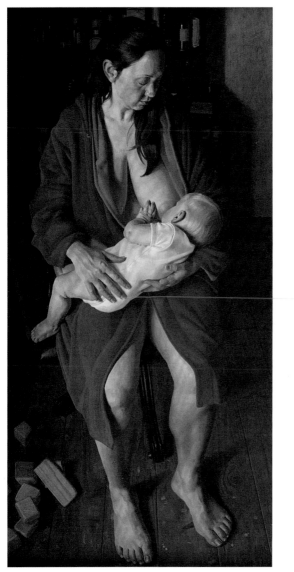

The winner of the 2017 BP Portrait Award, Benjamin Sullivan, has a long association with the competition; his work has now been selected a record thirteen times for the exhibition. Last year, he won third prize for his portrait of the poet Hugo Williams.

Several of these paintings have depicted members of Sullivan's family – a theme also present in this year's winning entry, which portrays his wife Virginia and their baby daughter Edith. The title, *Breech!*, refers to Edith's difficult birth, and the portrait was painted over five weeks in his studio at the family home in Suffolk.

'I have done many pictures of my wife over the years and having our first child seemed like a good reason to begin another,' he says. 'The portrait was started when our daughter was eight months old, as a sense of calm descended after the usual disarrangement that new parents face. Any later and it would have been a lot harder to do. Babies seem to become more aware of their surroundings at around eight to ten months.'

Aiming to convey 'the power of love and the bond between mother and child', Sullivan began with a drawing on paper, which he transferred to the canvas before underpainting and then painting with oil. 'I wanted the palette to be quite restrained and dusky, allowing the flesh to sing,' he explains. 'The dressing gown is painted thinly with subtle greys and violets allowing the green of the ground to show through.'

Sullivan was born in Grimsby in 1977 and graduated in Drawing and Painting from Edinburgh College of Art, where he was introduced to the work of his greatest influence, Stanley Spencer. 'I admire how Spencer focuses on the quotidian and depicts daily life with tenderness and compassion, somehow elevating it to become representative of a greater meaning,' he says. 'I share his use of distorted perspectives and my paintings probably have that slightly claustrophobic feel.'

He was elected to the New English Art Club and the Royal Society of Portrait Painters in 2001 and 2003 respectively – the youngest person to become a member of either institution. He was also artist in residence at All Souls College, Oxford, for many years and in 2008 he was commissioned to produce a large triptych depicting the college's non-academic staff.

Over the past year, he has returned to Oxford to draw developmental neuropsychologist Professor Dorothy Bishop as part of the university's Diversifying Portraiture Project, which aims to broaden the range of people represented around the university. He continues to combine commissioned pieces with his own family portraiture.

'You cannot help but feel differently painting your own family, I am sure, and this must affect the outcome to some degree,' he says. 'The emotional connection between sitter and artist is at the root of all successful portraits.'

Interview by Richard McClure

Double Portrait
Thomas Ehretsmann

Acrylic on board
300 x 400mm

Runner-up Thomas Ehretsmann was born in Mulhouse, France, in 1974, and now lives in Villé, a small town in the Vosges mountains. After training at the École des Arts Décoratifs de Strasbourg, he started out as a comic book artist, and currently makes his living as a book and magazine illustrator, for which he has won a number of awards. 'I don't consider myself a painter yet; I still have to work as an illustrator,' he says. 'I only get to paint once in a while.'

Ehretsmann's magazine work has included portraits of Bob Dylan for *Rolling Stone*, and Leonardo DiCaprio and Steven Soderbergh for the *New Yorker*, and he identifies both similarities and differences between his commissioned illustrations and fine-art portraiture. Typically, his illustrations are based on photographs of the subject found on the internet, while he also makes use of his own photographs when painting portraits.

'If I did an illustration and a portrait of the same person, the portrait would be based on reality, not on clichés,' he explains. 'In some ways, my painting is the opposite of my magazine work: there is no obligation to a client, no storytelling. But I also see my paintings as an extension of my illustration: a distillation, an improvement, but no rupture. They share the same mood – mostly intimacy, restraint and emptiness. I often feel Edward Hopper and Vilhelm Hammershøi are my kindred spirits.'

A period of study with Norwegian realist painter Odd Nerdrum (b.1944) encouraged Ehretsmann to devote more time to producing a personal body of work. In 2016, his portrait of a friend, Simon, pictured against a backdrop of the Vosges mountains, was chosen for exhibition as part of the BP Portrait Award. This year, he has been awarded second prize in the competition for a painting of his wife Caroline, a picture inspired by a walk in a local park some years ago.

'While we were walking, the light on Caroline's face reminded me of two French naturalist painters I love – Jules Bastien-Lepage and Émile Friant – and the way they used natural light,' he recalls. 'It's an undramatic light, but one that opens up all kinds of possibilities.'

Ehretsmann used a combination of life drawings and a photograph of Caroline to create his portrait, and painted in acrylic. It took five weeks to complete and was his third attempt at the painting over three or four years.

'Before, my technique was not good enough to express the right mood,' he says. 'The aim of my portraiture is to combine a fleeting emotion with a solid rendering, to transform an ephemeral thing into a timeless one. In order to achieve that, every inch of the picture has to have the same rendering, with no unfinished areas or expressive brushstrokes. This portrait works because every painted element in the face has a strong relation to the others. There is harmony here.'

Interview by Richard McClure

Emma
Antony Williams

Egg tempera on board
690 x 560mm

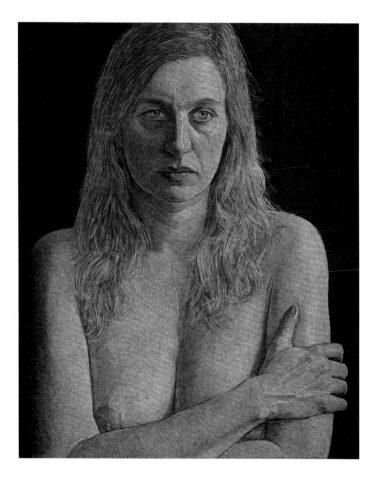

Antony Williams's long friendship with fellow artist Emma Bruce has proved to be a fruitful relationship for the Surrey-based painter. In 2015, his portrait of Emma, *Figure Lying by Water*, was selected for exhibition in the BP Portrait Award. Two years on, a second portrait of his friend, *Emma*, has now won third prize in the competition.

'Emma has been modelling for me continuously for the last eleven years,' says Williams. 'If the portrait is successful it is because it might possibly reveal some of Emma's vulnerability, but also her determination. A few years ago, she had to deal with the affliction of Bell's palsy, and although she has recovered, there are still residual traces that can be detected occasionally in her face.'

The portrait, completed over twenty sittings, was painted in egg tempera, which Williams has been using almost exclusively for more than twenty years. It is an exacting medium in which the pigment paste is mixed with an egg-yolk binder. Its quick-drying and water-resistant qualities mean that one application of paint can be rapidly followed by another without the two layers mixing. 'I find that because of the translucent nature of tempera, where underlying passages of paint influence what is superimposed on them, it is ideal for conveying the subtle nuances of colour found in skin.'

Williams was born in Kingston upon Thames in 1964 and trained at Farnham College of Art and Portsmouth University, later taking an illustration course in Cambridge.

'Although I did some sculpture and printmaking at college, I've always aspired to be a painter,' he says. 'I think it's something to do with the manipulation of paint, the process, and its ability to create an alternate reality in two dimensions. Over the last couple of years, I've been broadening my subject matter to encompass compositions where I've taken the model out of the studio and into an exterior location, such as a landscape.'

At first influenced by Constable, Vermeer and Rembrandt, his introduction to Lucian Freud's work in the early 1990s was a pivotal moment, persuading him to adopt an 'unflinching and direct' style. 'All my work is based on direct and intense observation of the subject matter, which can produce a heightened sense of realism,' he notes. 'Whether it's still life, portraiture or life painting, it is always treated with the same scrutiny – almost every surface detail is given equal attention.'

Williams's first solo show was in 1997 at London's Albemarle Gallery, and he has since held exhibitions in Madrid and Barcelona. Among his commissioned works are portraits of actor Donald Sinden, politician Margaret Beckett and Queen Elizabeth II, whom he painted at Buckingham Palace in 1996. 'I think painting Her Majesty The Queen has been my hardest challenge to date,' he says. 'I'd only painted a handful of commissioned portraits at that time, and the pressure of painting the monarch, and the onus on me to get it right, was enormous.'

Interview by Richard McClure

Gabi
Henry Christian-Slane

Oil on board
250 x 200mm

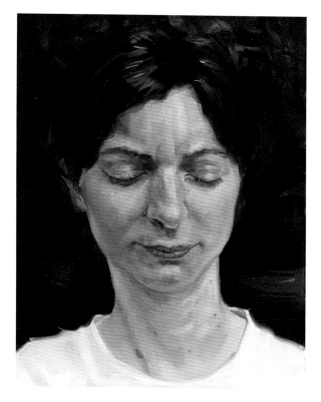

As the son of two illustrators, the winner of this year's BP Young Artist Award, Henry Christian-Slane, has been exposed to art his whole life. After briefly considering a career in science, he followed in his parents' footsteps, and graduated from Auckland University of Technology in 2011 with a degree in graphic design. He now combines a career in commercial illustration with exhibiting portraits and landscapes in his native New Zealand.

Themes of perception are central to his work, both in his portraiture and in other media. His computer-generated landscapes, for example, explore pareidolia – the psychological phenomenon in which the mind perceives a specific pattern or shape where none exists.

'It could be that my interest in science instilled in me a kind of distrust of my senses and the knowledge that what I think I'm seeing day to day is not at all similar to what is there if you look properly,' he explains. 'My portraiture revolves around breaking down what I'm seeing. The face is an incredibly subtle and complex subject that I don't think I will ever lose interest in.'

His winning entry is a portrait of his partner Gabi, who is also a graphic designer and artist. 'Gabi's mind and unique way of thinking continue to inspire me, and it was interesting to paint someone I know so intimately and had drawn so many times.'

Departing from his usual working methods of acrylic on canvas or paper, he painted Gabi in oil on primed hardboard over just two sittings in his Auckland studio. He began with a new technique and created multiple, quick drawings from different angles to instil an 'instinctual feeling' for what the sitter looks like.

'In the past I have focused heavily on carefully checked and refined preliminary drawings that take almost as long as the painting,' he says. 'This time, the speed prevented me from becoming too analytical. In hindsight I can see where the painting differs from life, but I feel I have captured something that I might not have been able to without such quickness.'

In 2014, Christian-Slane became the youngest artist ever to win the New Zealand Portrait Gallery's Adam Portraiture Award for a painting of his cousin Tim. The prize money helped fund an eighteen-month sojourn in London, where he lived in a warehouse with a dozen other creatives and worked at innovation production company Unit9.

Since returning to New Zealand, the 26-year-old has recently begun a series of painted portraits of friends and acquaintances, and is also preparing a solo exhibition of his experimental landscapes that can be viewed in virtual reality.

'I'm not the sort of artist who picks a way of working and then sticks with it for the rest of their life,' he says. 'Questions of who I am, what I want to say, and exactly how to say it, have always frustrated me. My biggest challenge is to find a single artistic voice and stick with it.'

Interview by Richard McClure

SELECTED
PORTRAITS

Antonio López
Jorge Abbad-Jaime de Aragón

Oil on canvas
1460 x 1140mm

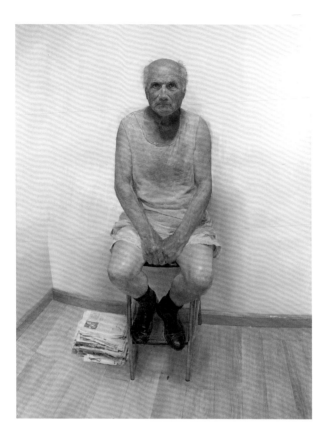

The Levinsons
Rupert Alexander

Oil on canvas
1349 x 1573mm

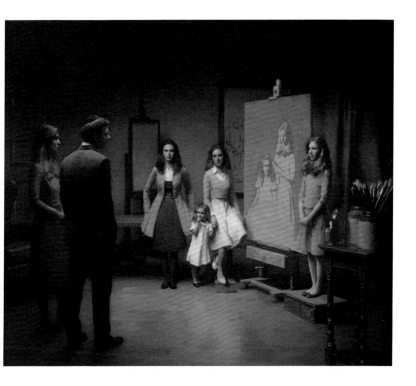

A Russian Artist in China
Bao Han

Oil on canvas
800 x 600mm

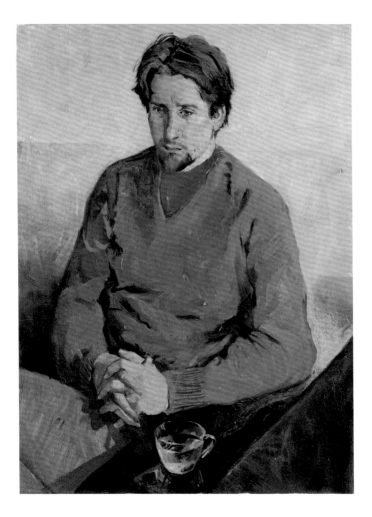

Carmel
Anne Ben-Or

Oil on linen
500 x 400mm

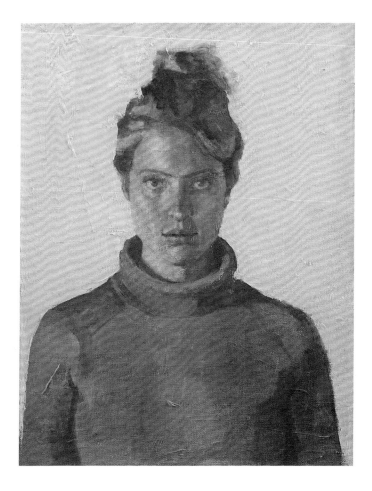

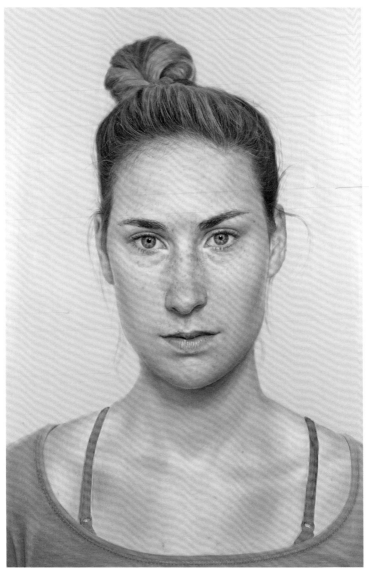

Nikki
John Borowicz

Oil on panel
406 x 305mm

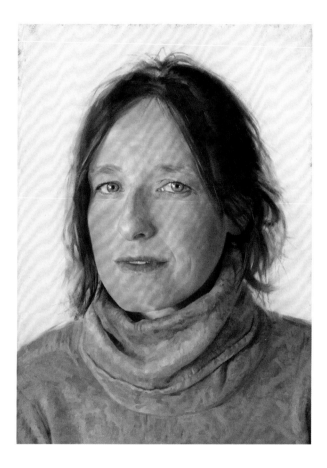

In the Shadows (Boy Meets Man)
Noah Buchanan

Oil on linen
737 x 559mm

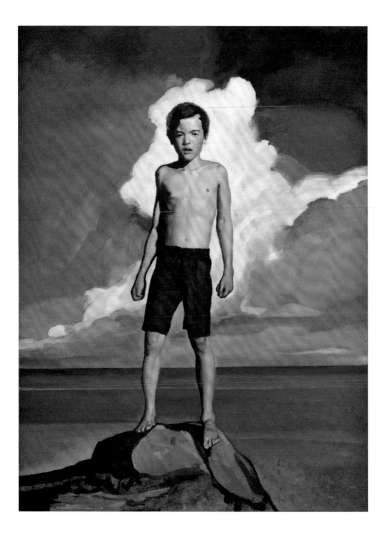

Matt Berry
Martyn Burdon

Acrylic on canvas board
520 x 620mm

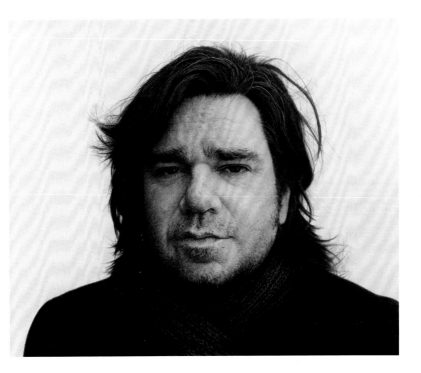

Pen Vogler
John Burke

Oil on panel
400 x 264mm

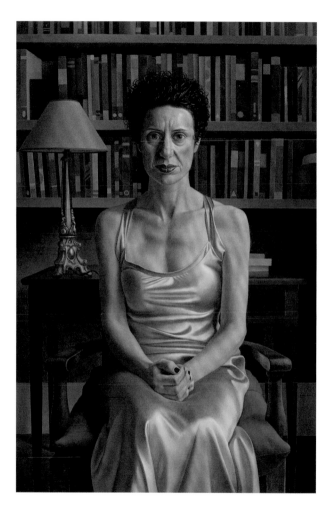

David Wigg
Sopio Chkhikvadze

Oil on canvas
1683 x 714mm

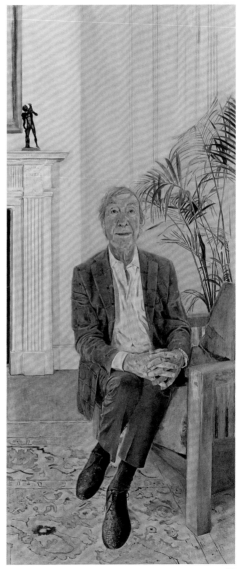

Honest Thomas
Alan Coulson

Oil on wooden panel
850 x 610mm

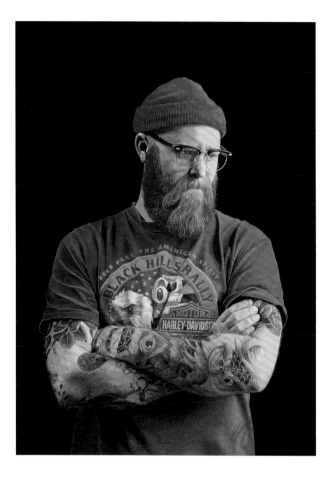

Blind Portrait
Daniel Coves

Oil on linen
1300 x 1150mm

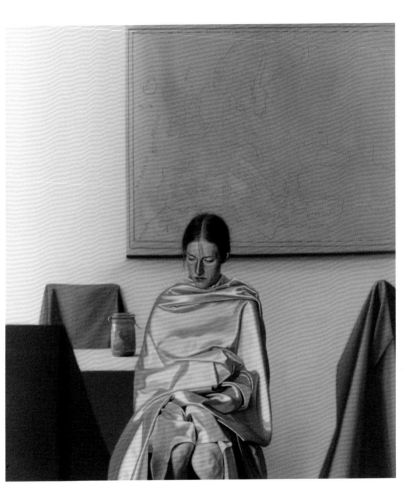

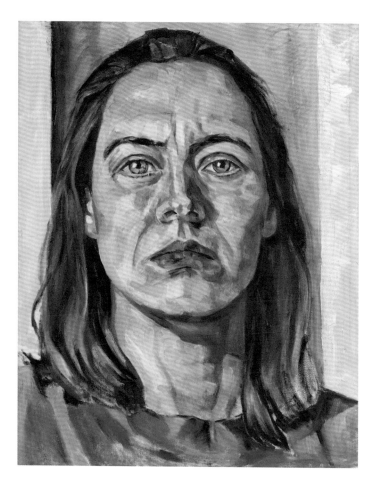

Another Fine Day On Elysian Fields
Avenue, NOLA
Éva Csányi-Hurskin

Oil on linen
610 x 450mm

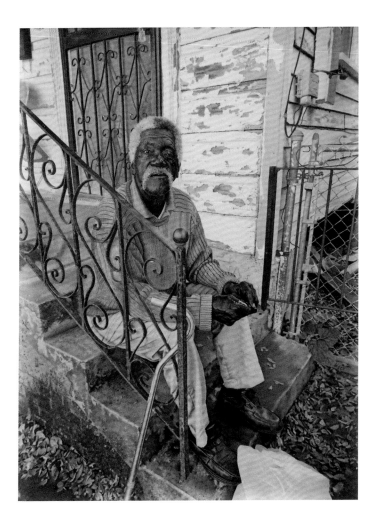

The Mayor of Woollahra
Sinead Davies

Oil on canvas
630 x 630mm

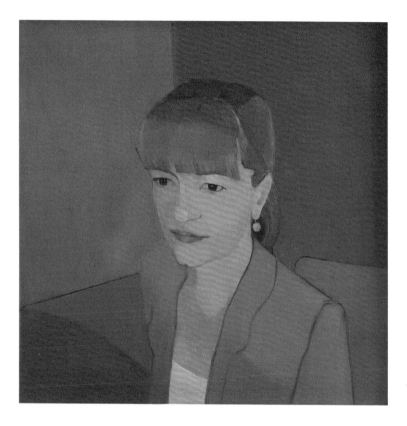

Robert
Estelle Day

Oil on board
400 x 400mm

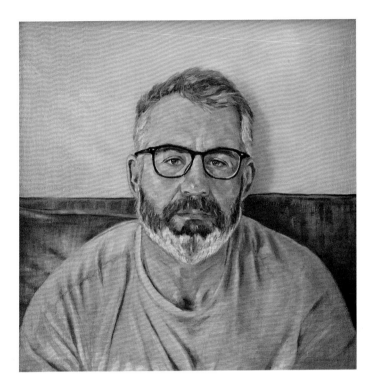

The Poets
Claire Eastgate

Oil and mixed media on canvas
1220 x 1220mm

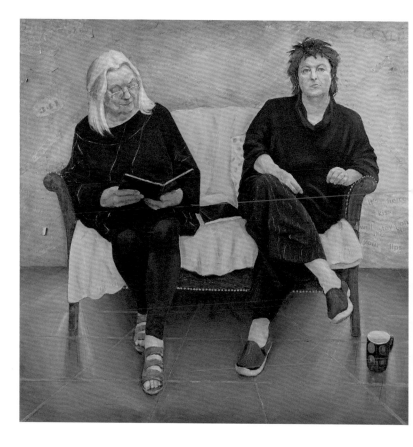

Cecilia
Madeline Fenton

Egg tempera and oil on gesso panel
450 x 350mm

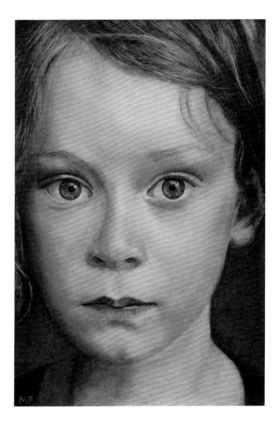

In a Diner, Somewhere in Manhattan
Maryam Foroozanfar

Oil on board
228 x 305mm

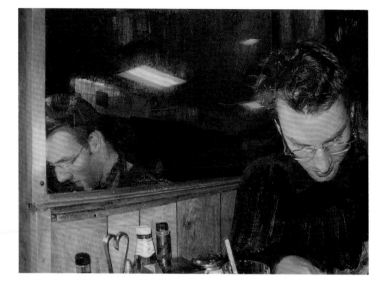

Carmen
Silvestre Goikoetxea

Oil on panel
1000 x 800mm

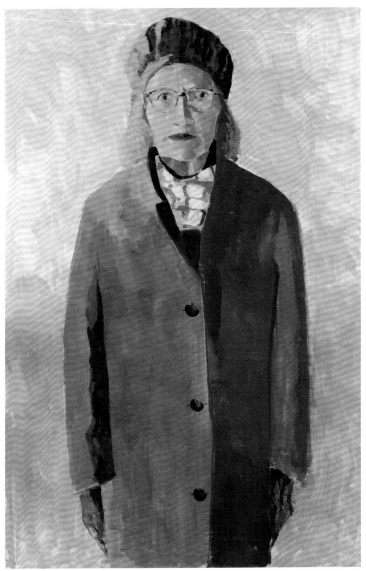

Lemn Sissay
Fiona Graham-Mackay

Oil on canvas
1111 x 861mm

Sarah
Raoof Haghighi

Acrylic on aluminium
400 x 300mm

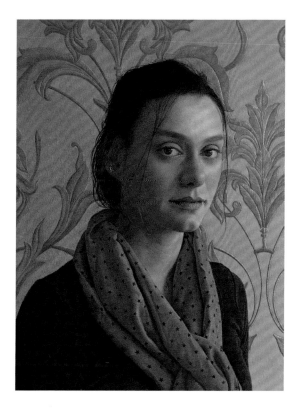

Ania
Ania Hobson

Oil on canvas
1370 x 1370mm

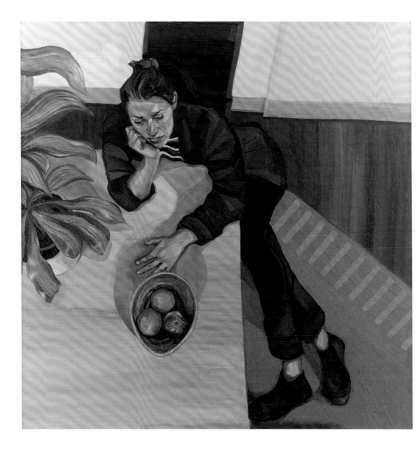

Tabitha Moses with Gilda, Liverpool
Hero Johnson

Oil on canvas
1600 x 1000mm

86 (Rhyming Slang for Worth Nix)
Janne Kearney

Oil on linen
1000 x 1000mm

Francesco
Anastasia Kurakina

Oil on canvas
350 x 350mm

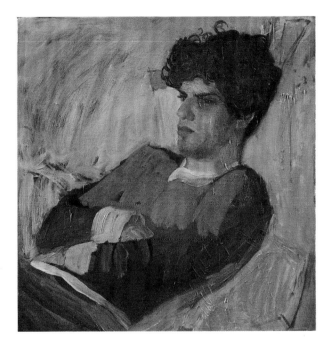

My Father Studying Form
Gary Lawrence

Oil on canvas
270 x 205mm

Oil on gesso board
457 x 457mm

Self-Portrait with Pear
Ross McAuley

Oil on canvas
610 x 510mm

Self-Portrait
Julian Merrow-Smith

Oil on linen
260 x 220mm

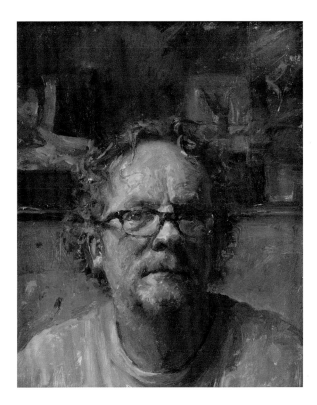

Granny Before She Passed Away.
Jose Antonio Ochoa

Oil on linen
760 x 680mm

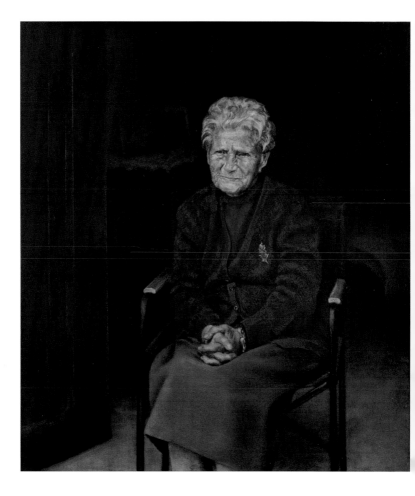

Portait of Beyza
Mustafa Ozel

Oil on canvas
270 x 220mm

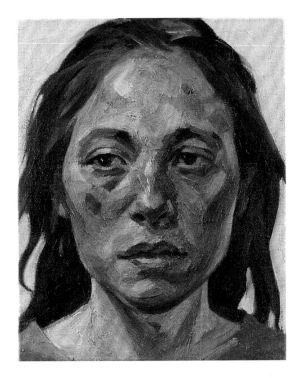

Corinne
Anastasia Pollard

Oil on board
255 x 205mm

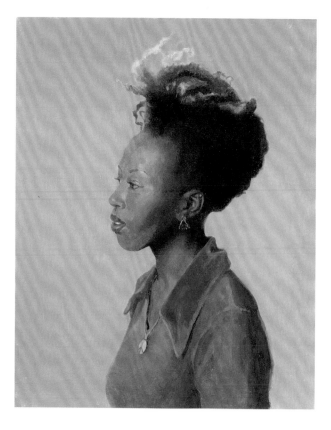

Jessica
Laura Quinn Harris

Oil on board
626 x 526mm

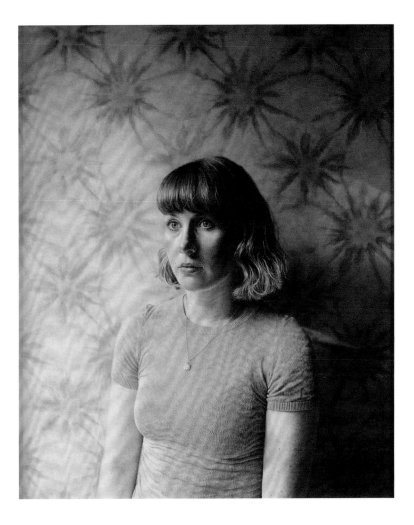

Ear (Oreja)
Simón Ramírez Restrepo

Oil on panel
275 x 355mm

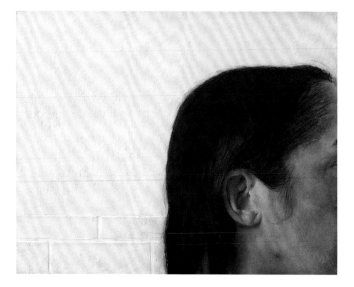

Profile
Angela Repping

Oil on board
460 x 610mm

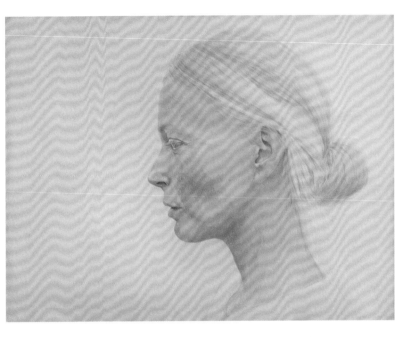

Delfin (1936)
Jesús María Sáez de Vicuña Ochoa

Oil on board
900 x 700mm

Portrait of Kane
Brian Sayers

Oil on panel
300 x 200mm

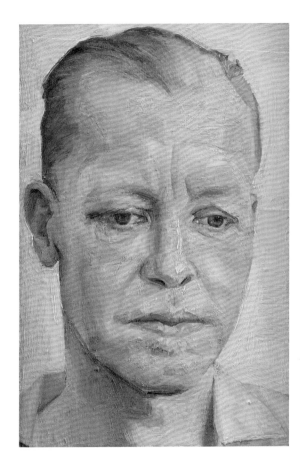

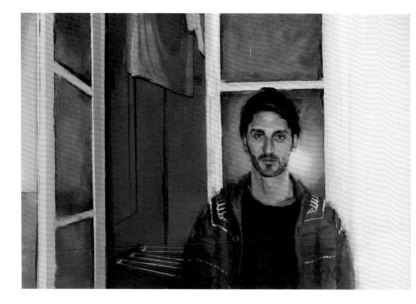

Archipelago
Brian Shields

Acrylic on canvas behind part-mirrored glass
830 x 970mm

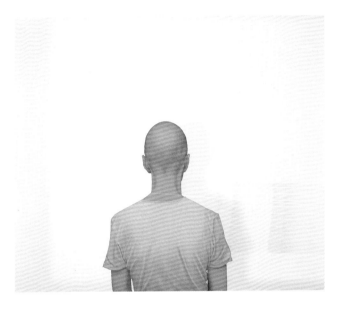

Alejandro
Anca-Luiza Sirbu

Acrylic on linen
970 x 1300mm

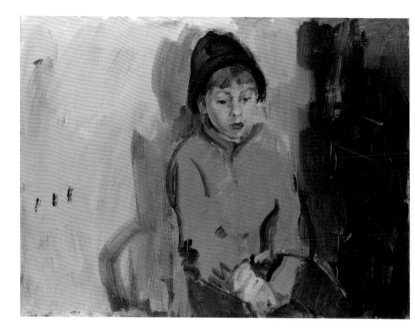

Norman Lamb MP
Paul P. Smith

Oil on canvas
840 x 570mm

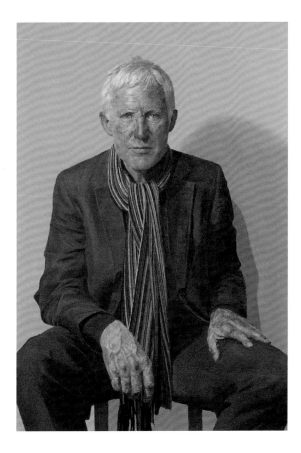

Annabel
Emily Stainer

Oil on canvas
250 x 200mm

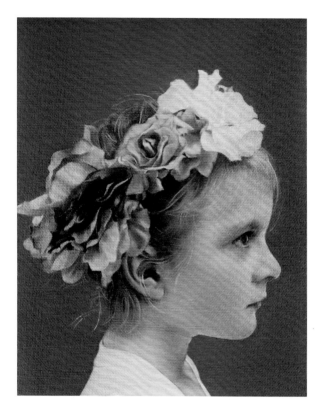

Portrait of the Artist Jerome Witkin
David Stanger

Oil on linen
510 x 410mm

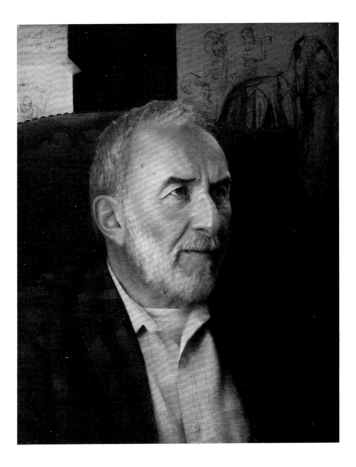

Dr Tim Moreton
Lucy Stopford

Oil on canvas
650 x 495mm

Society
Khushna Sulaman-Butt

Acrylic and oil on canvas
1670 x 2230mm

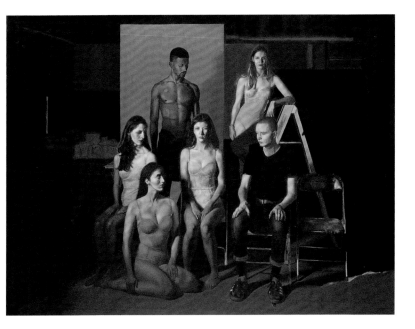

Ken Loach
Richard Twose

Oil on linen
2000 x 1500mm

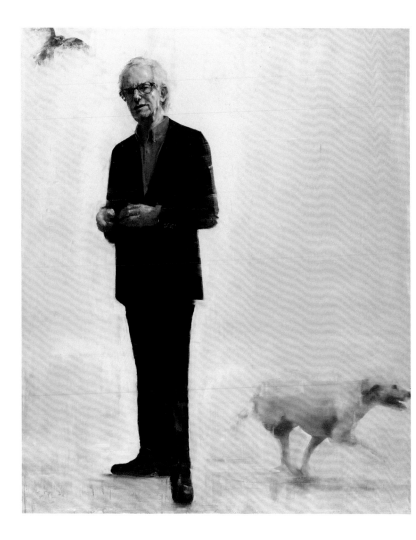

S. at End of Summer
Marco Ventura

Oil on panel
360 x 280mm

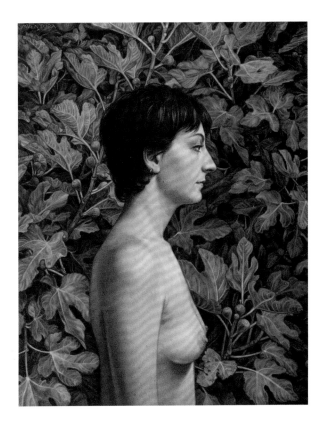

Jack
Casper White

Oil on zinc
400 x 300mm

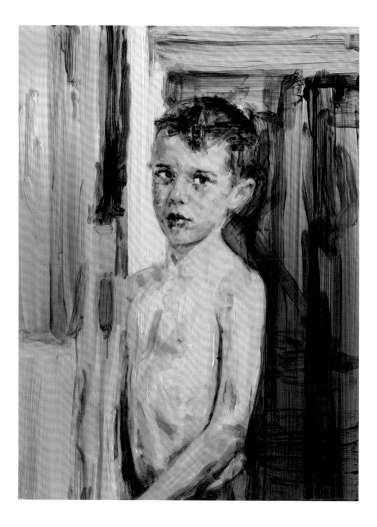

BP TRAVEL AWARD 2016

Each year exhibitors are invited to submit a proposal for the BP Travel Award. The aim of this award is to give an artist the opportunity to experience working in a different environment in Britain or abroad, and on a project related to portraiture. The artist's work is then shown as part of the following year's BP Portrait Award exhibition and tour.

THE JUDGES

Paul Moorhouse
Senior Curator of Twentieth-Century Collections, National Portrait Gallery

Richard Twose
Artist

Des Violaris,
Director, UK Arts & Culture, BP

The Prizewinner 2016
Laura Guoke, who received £6000 for her proposal to travel to a refugee camp in Greece.

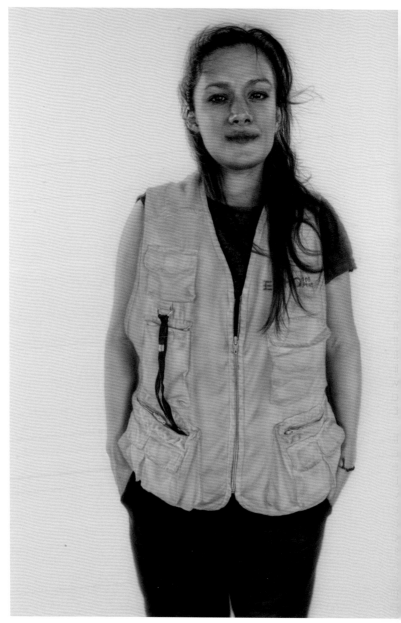

Monica by Laura Guoke, 2016
Acrylic on canvas, 1500 x 1000mm

PORTRAITS FROM THE RITSONA REFUGEE CAMP

Laura Guoke

Since the first shots of the Syrian civil war were fired six years ago, more than half the country's population - around eleven million people – has been forcibly displaced, with five million fleeing to other countries. The humanitarian crisis created by the conflict is reflected in the BP Travel Award, for which the recipient in 2016, Laura Guoke, spent two weeks in a Greek refugee camp documenting the faces and stories behind the statistics.

The 30-year-old has long combined a successful artistic career with extensive charity work in her native Lithuania and believes that 'the work of an artist should bear a meaningful message'. Her most recent gallery exhibitions have addressed social and political issues, including an installation in response to Russian aggression in Ukraine, and a series of unique portraits (that glow in the dark) in acrylic, and videos depicting the hardships of life in a Lithuanian village.

Guoke's interest in the Syrian crisis was sparked by her ongoing voluntary work for the Children's Charity and Support Fund. It is an organisation that provides help for poor families in rural areas of Lithuania, and for children whose parents sustained injury and disability during service in the Soviet Army, including those exposed to radiation during the clean-up of the Chernobyl nuclear power plant following the disaster in 1986.

'I am more and more convinced that the works created by artists should encourage people to understand, to sympathise, to admire and to wonder what could be done by each of us,' says Guoke. 'The situation of the Syrian refugees should be considered by everybody. Circumstances could change one day and any one of us could be compelled to live in a tent with no water or chance to escape.'

Born in Kaunas, Lithuania's second largest city, Guoke graduated with a BA in Fine Arts from Vilnius Academy of Arts and an MA from Šiauliai University. Her work has been seen in group exhibitions in London, New York and Vienna and in several solo exhibitions in Lithuania, Latvia and Estonia. For the BP Travel Award, Guoke stayed and worked at the Ritsona refugee camp in Greece for two weeks in September 2016, helping out at the food distribution centre while also producing a number of sketches and laying the groundwork for her two large-scale portraits.

'I didn't think it would be right just to go there to carry out my artistic project; I wanted to be helpful,' she explains. 'Meal vouchers are given to each tent in the camp and the food is distributed three times per day, with volunteers working in shifts.'

The camp is situated on an abandoned military base an hour north of Athens and has around 900 residents, 400 of whom are children. The population is roughly two-thirds Syrian, with the remaining third made up of Kurds, Iraqis and Afghans.

Ritsona is one of dozens of camps throughout Greece administered by the government and aid agencies

and was set up when Europe closed its borders in March 2016, resulting in the country becoming a vast holding pen to around 50,000 refugees. At the time of Guoke's visit, Ritsona was designated a 'red camp' by the United Nations due to inadequate toilets, showers, electricity and medical care.

'The camp is located in the middle of nowhere, surrounded by empty fields, olive trees and derelict factories,' says Guoke. 'The first impression is of children everywhere. The residents come from all backgrounds – I even met singers and musicians – and you soon perceive their pain. They show you the photographs of their homes that have been destroyed in Syria – the photographs of the life they used to have before the war.'

After explaining to residents the purpose of her visit, Guoke made dozens of sketches of people she met in the camp. She eventually selected her two main subjects: Rima a Syrian mother-of-five, whom she pictured with her baby son Ahmed; and Monica, a Swiss volunteer.

'I chose the two women for many reasons, including gender, their similar ages, and their very different life experiences,' she explains. 'From the very first day I had an idea how

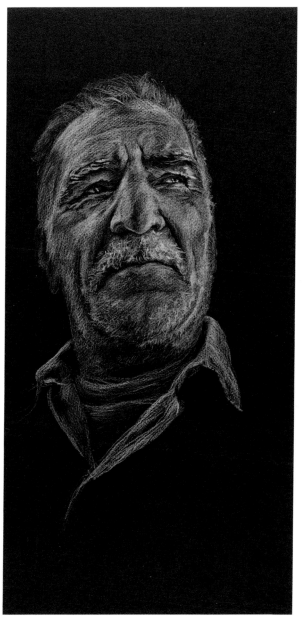

Abo Rashed by Laura Guoke, 2016
Pastel on paper, 500 x 250mm

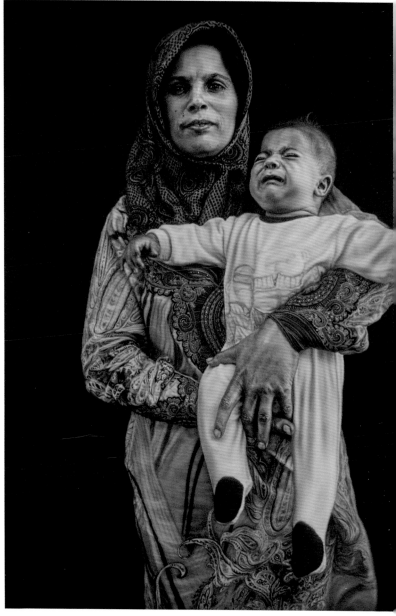

Rima and Muhammed Ahmed by Laura Guoke, 2016
Acrylic on canvas, 1500 x 1000mm

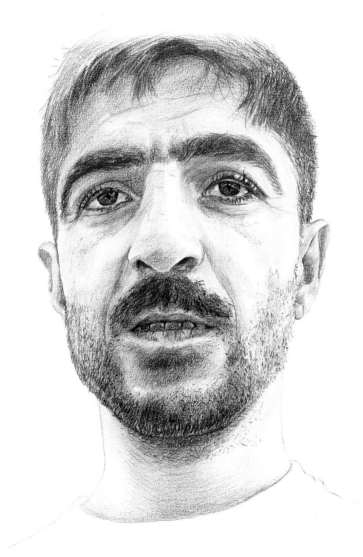

Muhammed Bashar by Laura Guoke, 2016
Graphite on paper, 410 x 300mm

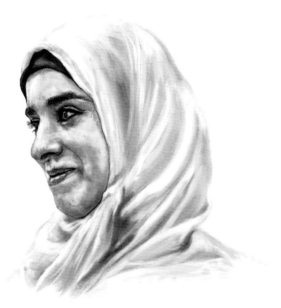

Abeer Jamal by Laura Guoke, 2016
Charcoal, pastel on paper, 410 x 500mm

the two portraits should be displayed together, and I adjusted the size of the paintings, composition, and the subjects' gaze to the viewer to create portraits that worked together as a pair.'

Rima had arrived in Greece with her husband Mohammed and their children after escaping Aleppo and had been living in Ritsona for several months. Ahmed, their fifth son, had been born in Athens during their 1400-mile journey to safety. By contrast, Monica was volunteering at the camp for a second time, having put aside her studies in business administration. 'Our society should be proud of these volunteers, who have come from all over the world to carry out difficult work for free,' says Guoke. 'This is why I created a portrait of a volunteer. Monica is one out of many ordinary men and women who have acted selflessly to provide aid for others.'

After drawing both sitters several times and taking photographs to use as supporting material, Guoke made the portraits back at her studio in Pavartyčiai, choosing to picture Rima against a black background and Monica on a white canvas as a means of representing their contrasting circumstances. 'The black canvas illustrates the darkness surrounding the refugee's life – the dark from which they wish to escape. In the portrait of Monica, the background is left white to represent the world to which the refugees seek to belong.'

Wishing to 'speak through all possible means', Guoke works across a diverse range of media, including silkscreen printing, pastel on metal, photography, text and video installations. For her Ritsona portraits, she used acrylic, with each photorealistic portrait taking around three months to complete. 'Acrylic allows me to cover almost transparent layers of paint one after the other, helping me to convey particularly sensitive tonal details,' she says. 'This assists in creating the mood of the portrait as well as revealing the individual characteristic features of the sitter. In order to achieve any kind of progress, I need to paint for at least eight uninterrupted hours every day. It is almost like meditation.'

Since leaving the camp, Guoke has kept in touch with both women. Rima and her family are currently living in Athens and remain hopeful of being resettled in Ireland, while Monica is about to embark on her third spell of volunteering at Ritsona. 'Working at the camp has been a very intense experience for Monica. After her

second time, she felt much more connected with the people and didn't want to leave. She saw the success that a group of people can achieve together.'

Meanwhile, Ritsona has undergone partial improvements with the tents replaced by small container-like cabins, and the construction of more washroom facilities, a children's zone and a sports area. However, the *New York Times* reported in April that conditions are 'unpleasant at best', with families packed into tiny rooms and only a fraction of the children admitted into government schools, where classes are conducted exclusively in Greek.

'With the closure of the borders, many Syrian people have stayed in the dark and will never reach the light. We will never know their life stories,' concludes Guoke. 'With my pieces of art, I have attempted to reveal the trauma, exile, hopes and fortitude that have marked the lives of the refugees. I hope I have been able to convey very personal themes in my portraits that may otherwise be difficult to put into words.'

Interview by Richard McClure

ACKNOWLEDGEMENTS

My congratulations are offered to all the artists in the exhibition and especially to the prizewinners, Benjamin Sullivan, Thomas Ehretsmann and Antony Williams, and to Henry Christian-Slane, the winner of the prize for a younger painter. I am also grateful to all the artists who entered the 2017 competition.

I would like to thank my fellow judges: Camilla Hampshire, Sarah Howgate, Michael Landy, Des Violaris and Kirsty Wark. They were attentive and knowledgeable regarding the task at hand and it was a pleasure to work with them all. I should also like to thank the judges of the BP Travel Award: Paul Moorhouse, Richard Twose and Des Violaris. I am very grateful to Stella Duffy for her engaging essay for the catalogue. My thanks too to Kathleen Bloomfield and Richard McClure for their editorial work, Richard Ardagh Studio for designing the catalogue, and to Clementine Williamson and Keeley Carter for their overall management of the 2017 BP Portrait Award exhibition, ably assisted by Alice Bell. Many other colleagues at the National Portrait Gallery have been involved in making the competition and exhibition a continued success and my thanks for their hard work go to Pim Baxter, Robert Carr-Archer, Neil Evans, Ian Gardner, Dan Isitt, Laura McKechan, Justine McLisky, Ruth Müller-Wirth, Nicola Saunders, Fiona Smith, Liz Smith, Emily Summerscale, Christopher Tinker, Sarah Tinsley and Rosie Wilson. Many thanks to The White Wall Company for their contribution to the efficient management of the selection and judging process.

Nicholas Cullinan
Director, National Portrait Gallery

INDEX